T0079727

ERNST LUDWIG KIRCHNER

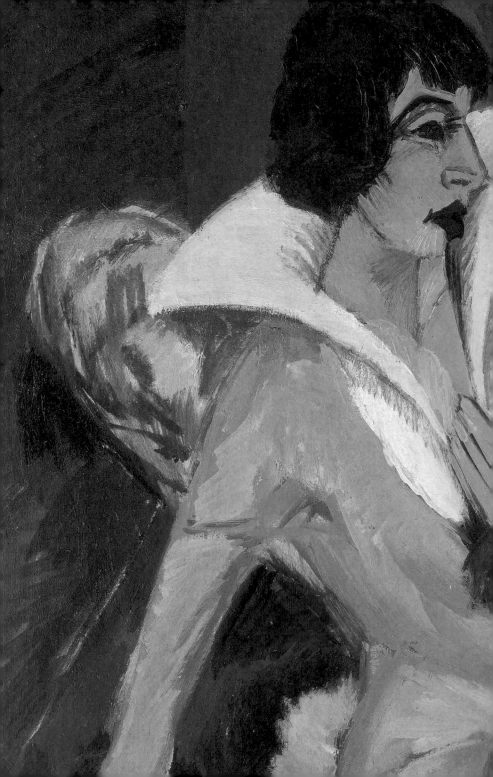

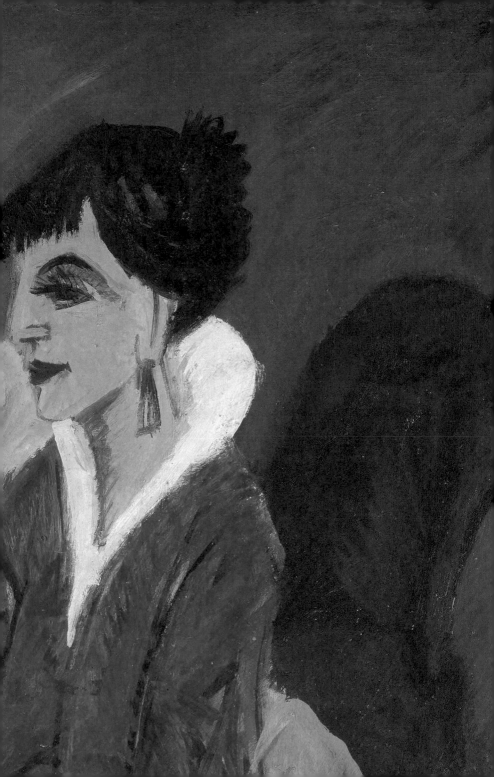

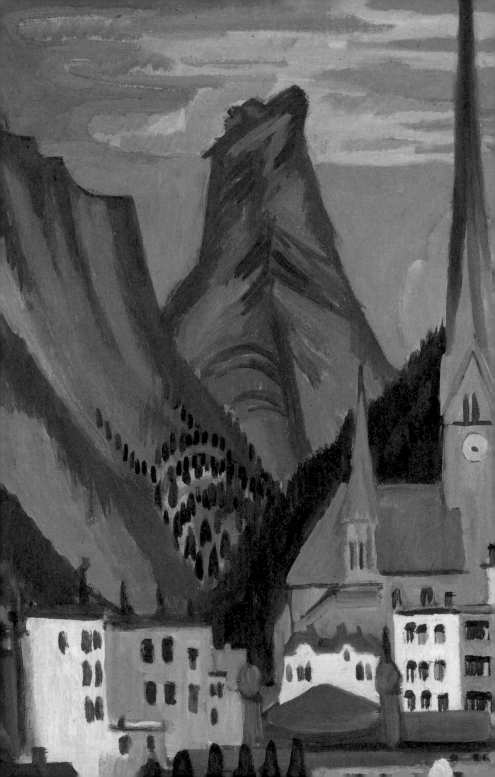

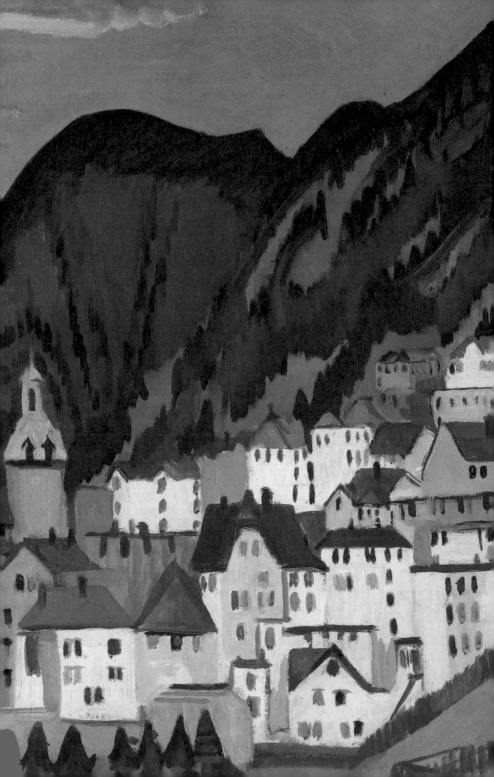

ERNST LUDWIG
KIRCHNER

Thorsten Sadowsky

HIRMER

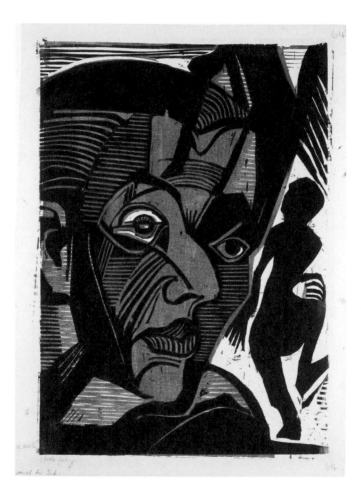

ERNST LUDWIG KIRCHNER
Melancholy of the Mountains (Self-Portrait), 1929, colour woodcut
Graphische Sammlung, Städel Museum, Frankfurt am Main

CONTENTS

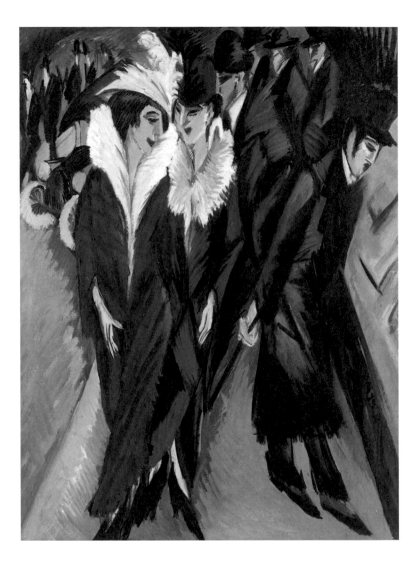

1 *The Street*, 1913, oil on canvas
Museum of Modern Art, New York

ERNST LUDWIG KIRCHNER'S JOURNEY INTO THE MOUNTAINS

Thorsten Sadowsky

In them the most discordant contents sit cheek by jowl in the smallest of spaces. Within minutes the excitement-hungry mind can travel pleasurably from one pole to another of an entire world of artistic projects and sample the most distantly related varieties of sensibility.[1]

Georg Simmel

ART WORLD AND WORLD CITY

The Berlin philosopher and sociologist Georg Simmel was among the most original observers of the art world in the German capital around 1900. To Simmel the art exhibitions of his time were a microcosm of urban life with all its extremes, excitements and pleasures. Art exhibitions, he wrote, are fleeting; they exist in a restless "eight-week cycle" and scatter their contents to the four winds when they end. In Simmel's view, the experience of an art exhibition with its welter of diverse impressions creates a sensory overload, which is why the modern perception of art responds to it with a blasé attitude and superficiality.[2] He compared the intensity of sensations provided by an art exhibition with that of the modern metropolis where, again, only the reserved detachment of the urbanite could counteract the nervous strain which at the time was called neurasthenia.

Neurasthenia was an invention of the late nineteenth century. Originally a medical term but soon popularised as "nervousness", it referred to a chronically irritable and overstrained mental state at the interface between illness and health. Neurasthenia was a *zeitgeist* disease, one that particularly afflicted the restless urbanites whose world was undergoing dramatic change around 1900 as a result of technological modernity and acceleration.[3]

Emergent Berlin in particular, the "Parvenu City" among the European metropolises, had undergone rapid development since the 1870s and by the turn of the century already presented itself as "Chicago on the Spree". By 1905, its population had grown to two million and with the creation of the "Administration Union of Greater Berlin" in 1911 it increased to almost four million, making Berlin the second largest city in Europe after London. The population of Berlin was young, forward-looking and grew as a result of unprecedented immigration, which frequently prompted comparisons with America. Berlin was the largest and most modern industrial centre in Germany at the time, a metropolis where the most innovative industrial sectors, the electrical and chemical industries, were concentrated. The electricity industry was the catalyst for the cult of light and electricity which mesmerised Berlin from an early date and was eventually encapsulated in the 1920s in the term "Electropolis". The big city with its innovations, contradictions, paradoxes and asynchronicities forced its denizens into "inner" urbanisation.[4]

Georg Simmel describes the "indifference towards the meaning and differing values of things" as a collective human act of adaptation to the urban environment. The result is a blunting of perception in response to the visual and acoustic impositions of the big city.[5] Paradoxically, the adaptation to the changing environment and the increasing wealth of stimuli gives rise to a need for ever new experiences. The urban type of the *flâneur* is the one who jolts the dulled nerves through the search for the new. Lost in thought, he aimlessly and insouciantly strolls along boulevards, through arcades and exhibitions and takes in the multifarious aesthetic sensations of the urban *merkwelt*.

The *flâneur* is regarded as the individualistic hero of modernity, as an aesthetic dissident in the age of acceleration. He is a literary retro-figure of the nineteenth century who keeps reappearing as a dandy revenant on the stages of the city. *Flânerie* is the most exclusive and therefore most

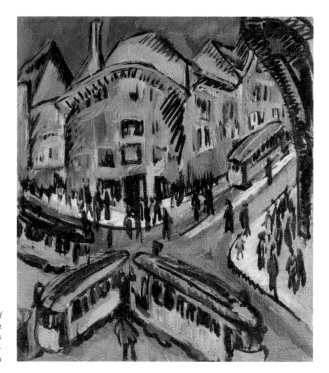

2 *Nollendorf Square*, 1912
Oil on canvas
Stiftung Stadt-
museum Berlin

fascinating form of perception and self-presentation in urban public life. The *flâneur* stands out among pedestrians because he despises the speed and the rush and refuses to subject himself to the big city's economy of time. At the same time his distinct aesthetic individualism and his refusal to let the city become habitual identify him as a decidedly urban phenomenon. For he confirms unintentionally as it were the typical forms of communication and behaviour of the urbanite who responds to the detachment from traditional bonds and to mass culture in the city by making every possible effort to express his uniqueness and distinctiveness.[6]

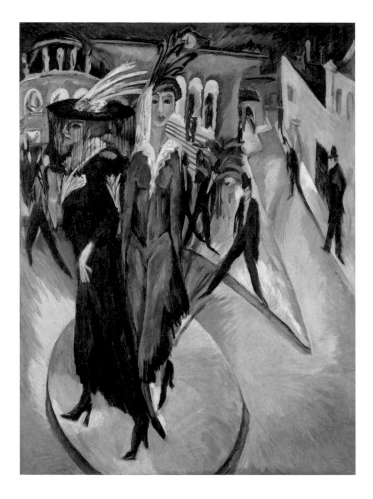

3 *Potsdam Square*, 1914, oil on canvas
Staatliche Museen zu Berlin, Nationalgalerie

In Ernst Ludwig Kirchner's famous painting *Potsdam Square* (3), male figures circle around two elegant *demi-mondaines* who appear at midnight on a traffic island in the centre of the square. Different perspectives, the wedge-shaped streets and the opposite movements of the men and women create a sweeping dynamic that threatens to explode beyond the boundaries of the pictorial space. The square in *Potsdam Square* appears primarily as a revolving stage of episodic, noncommittal contacts, on which the protagonists are pulled into a whirl of movements. A blasé and reserved attitude dominates the scene, for in spite of the nervous, erotic atmosphere the mask-like women and faceless men fail to make contact. Kirchner's choreography is based on basic geometric forms. The centre circle and vigorous diagonals are orchestrated by the protagonists' triangular leg pairs. Glances, turns and the orientation of the bodies in the urban space visualise attraction and repulsion alike.

This painting paradigmatically demonstrates that Kirchner looked at the metropolis of Berlin with anything but the eyes of a social critic. Instead, he apparently acted as a *flâneur* who drifted through the city in order to bring the images found in the urban diversion subsequently to canvas. The crowd, which is in constant motion and offers ever new constellations, acts as his counterpart. He depicts pedestrians' different ways of walking,

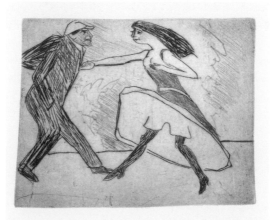

4 *Apache Dance*, 1911
Etching
Kirchner Museum Davos

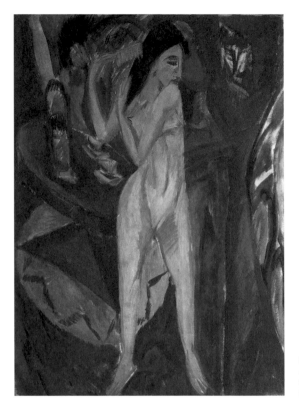

5 *Nude Woman Combing
Her Hair*, 1913
Oil on canvas
Brücke-Museum Berlin

which seem to be guided as if by an unseen hand by the rhythm of the city.
Kirchner's Berlin works reflect an extraordinary sensitivity to the specific
perceptual order in the big city, to the synchronicity and abruptness of
impressions and the heightened dynamic of seeing. He succeeded better
than most other Modernist visual artists in capturing in his street scenes
the seductions and impositions of metropolitan life. *Potsdam Square* is a
highly ambivalent and powerful icon of Berlin that condenses a variety of
visual stimuli, sudden movements and moments. The street scene makes
the subculture of prostitution in urban public space visible; what usually
happens covertly in cafés, arcades, cabarets, dance halls and bars is brought
onto the stage of the city here. The young progressive Berlin artists and
writers act like "Apaches" (4) in the urban jungle and seek adventure at the
margins of bourgeois society.

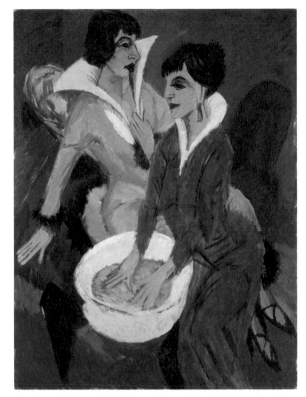

6 *Two Women with Washbasin (The Sisters)*, 1913
Oil on canvas
Städel Museum,
Frankfurt am Main

Attentive chroniclers sifting through the postcard correspondence between Ernst Ludwig Kirchner and Erich Heckel in the period from 1909 until 1912 have counted no fewer than twenty different female names. Kirchner's obvious promiscuity seems to have abated in the years that followed. Indeed, a survey of the subjects of the total of 1,045 paintings listed in the catalogue raisonné by Donald E. Gordon also indicates a "slow-down": in the period from 1902 until 1914 subjects belonging to the umbrella topic "women and nudes" make up about 42 percent of his artistic output, while for the period from 1915 until 1938 the percentage of female subjects drops to about 15 percent.[7]

In 1911–12, Kirchner met the sisters Gerda and Erna Schilling in Berlin's nightlife and eventually decided in favour of Erna. They ended up living together until his death in 1938. Erna became the artist's most important

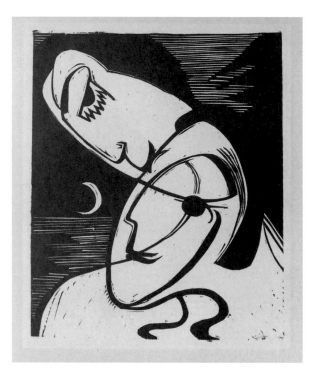

7 *The Kiss*, 1930
Woodcut
Kirchner Museum
Davos

person of reference who, as lover, model, collaborator, critic, dialogue partner and intermediary, took on a great number of roles. Intimately entwined two-circle figures and sculptures from the Davos period show this quasi-symbiotic merging (7).[8]

And yet Ernst Ludwig Kirchner's Davos diary, in which the artist confided in the period from 1919 until 1928, begins with a "Dodo reverie" referring to Doris Grosse, who had been his lover in the late Dresden years (see p. 72). Kirchner describes how Erna Schilling had brought him his carpet in which he would roll himself up in times of crisis, in order to compose himself: "Today the desire for the carpet was so strong that E got it for me. Now I am lying in it. How beautiful it is. Which faraway Caucasian woman has woven her life into it as you do, Dodo, with your industrious hands. Silent, dainty and so white and pretty. Your lovely fresh appetite for love: with you I experienced it to the full, almost to the point of endangering my destiny."[9]

Kirchner employed photography as a means of self-representation and a way of staging his life as an avant-garde bohemian artist.[10] In a way, he delegated to photography the task of presenting his life vision of increasing spiritualisation in the proper light. Kirchner's nervous breakdown during his time in the military in Halle, his self-destructive addiction to Veronal and morphine and his subsequent odyssey through German and Swiss sanatoriums eventually resulted in a cult of genius with literary accompaniment that came into full effect in the Alpine purgatory near Davos. At least this is where his transformation from a hyper-nervous urbanite into a Rousseauesque existence in a rural community seems to have taken place. There is visual evidence of his "going native" in an Alpine environment, such as his appearance in a peasant jacket at a folkloristic dance upstairs at his *Lärchen* house (37).

The perpetually smoking Kirchner with his penchant for an excessive lifestyle becomes an iconic self-projection of the artist, linking appearances as a uniformed soldier with self-portraits from the 1920s; invariably, the cigarette is the obligatory prop of nonchalant, aloof coolness (9, 36). Also part of the artist's image is his pronounced disposition to polytoxicomania, that is, his simultaneous addiction during certain periods of his life to multiple medications or drugs in combination with alcohol. As early

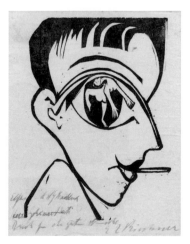

8 *Profile Head Self-Portrait*, 1930
Woodcut
Kirchner Museum Davos

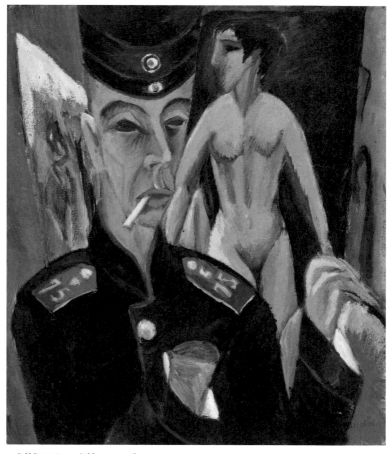

9 *Self-Portrait as a Soldier*, 1915, oil on canvas
Allen Memorial Art Museum, Oberlin College, Ohio

as 1916, while staying at the sanatorium in Königstein im Taunus, he was diagnosed with a strong addiction to medications. In 1921, under the care of Helene Spengler, the wife of Dr. Lucius Spengler, his first physician in Davos, Kirchner made an attempt to withdraw from the use of opiates. In the early 1930s, after a number of relatively stable years, Kirchner had Dr. Frédéric Bauer, his physician and collector, regularly prescribe him the morphine surrogate Eudokal, to which he remained addicted until his death.[11]

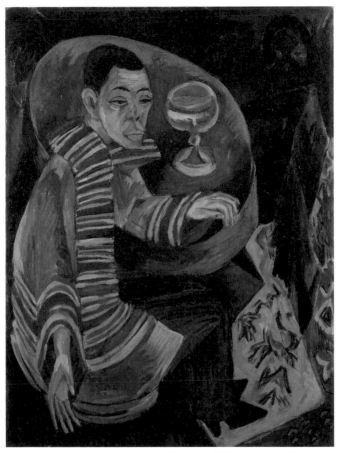

10 *The Drinker (Self-Portrait)*, 1914, oil on canvas
Germanisches Nationalmuseum, Nuremberg

CONTRADICTIONS

Ernst Ludwig Kirchner has long been canonised as one of the most important artists of German Expressionism, as well as being regarded as a particularly complex and contradictory artistic personality. Kirchner's work comprises a closely interwoven interplay of different media – photography, painting, drawing, printmaking, textile art, arts and crafts and sculpture – which, taken together, constitute one of the most extensive and

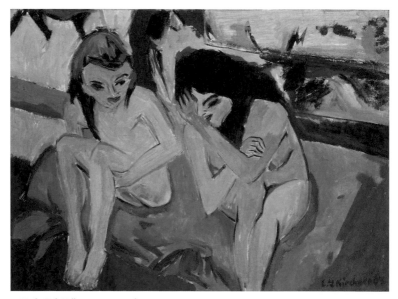

11 *Nude Girls Talking*, 1909–20, oil on canvas
Museum Kunstpalast, Düsseldorf

important oeuvres of the twentieth century. Like Vincent van Gogh and Edvard Munch, Ernst Ludwig Kirchner embodies paradigmatically the myth of the highly sensitive artist who found the impositions of life diffi-cult to endure. While his early work of the "Brücke" period is thoroughly informed by the young erotomaniac savage and a sense of new artistic de-parture, the Berlin period from 1911 until 1917, which was interrupted by stays in various sanatoriums, is subsumed under the category of the neur-asthenic, meaning the nervous, anxiety-ridden artistic soul who crosses the boundaries of normality. Kirchner's Davos period from 1918 until 1938, on the other hand, is initially dominated by his recovery in Alpine sur-roundings and ultimately classified as a "new style" which effects a turn towards an abstracted and, in terms of surface, calmer vocabulary of forms. From the mid-1920s on, Kirchner's late Davos work shows a clear

12 *The Wanderer*, 1922, etching
Kirchner Museum Davos

trend towards abstraction, revealing a decisive appreciation of contemporary Modernism in the form of Post-Cubism, Surrealism and Bauhaus.[12]

Kirchner is often portrayed as a vitalistic, rigorous protagonist of Expressionism whose fate as an artist almost inevitably finds fulfilment in the role of martyr and prophet, with the catchwords supplied by Friedrich Nietzsche's Dionysian, rhapsodic calls for ecstatic affirmation of life and self-exhaustion. The final phase of Kirchner's life and work in the mountains near Davos, in particular, appears to be consistent with this Nietzsche-informed fatefulness, since Zarathustra, the great lonely one, retreats in similar fashion to the sublime mountains.[13] In particular the subject of the wanderer, which Kirchner addressed repeatedly in 1922, seems to confirm this ultimate inevitability, as the artist, leaning on a stick, walks away between massive mountainsides (12). Even when this figure was originally conceived as a portrait of Henry van de Velde, the Belgian architect (13), it does show above all an exhausted artist figure on the final leg of his life's journey.

But this alleges a stringency and inevitability which belies the obvious contradictions in Ernst Ludwig Kirchner's character and work. Although Kirchner stylised himself as an outsider, he pursued his career with great dedication and ambition. In keeping with the zeitgeist, he was very interested in the art of West Africa and Oceania and adopted various

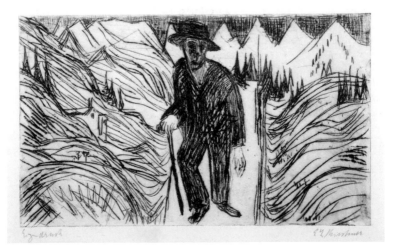

exoticisms in his works and his studios; moreover, familiarity with French avant-garde art was critical to his artistic development. Nonetheless it is above all as an "armchair traveller" that we see Kirchner, drawing his extensive knowledge primarily from ethnological collections, books and art magazines. Kirchner never travelled outside of Europe, nor did he visit Paris, Amsterdam, London or Rome and from 1917 on his exhibition and museum visits were relatively few and far between. Instead, he invented his own art critic under the pen name of Louis de Marsalle and tried to influence the reception of his work in this way. Although Kirchner had retreated to the Swiss Alps, he was extremely well informed and despite his consistent absence in person he was more present than most artists in German exhibitions in the 1920s. Although Kirchner saw himself as a painter of movement, his life in Switzerland appears oddly static and secluded. He regarded himself as one of the most important and original German artists of his time, and yet at the same time he became involved in local rural cultural life. He designed, for instance, the sets for peasant farces and comedy performances by amateur drama groups in Frauenkirch near Davos. Despite the fact that Kirchner was subject to increasing marginalisation in National Socialist Germany – 639 of his works were confiscated in German museums after 1936 – he still clung for a long time to his German identity and continued to insist that he was a German artist in the tradition of Albrecht Dürer.[14]

Another contradiction in Kirchner's personality was the fact that both anti-Semitic passages and occasional statements against the discrimination of Jews can be found in the artist's diary entries and his extensive correspondence with friends, collectors and art historians. In one of the last written documents he left behind, under the heading "January 38", Kirchner summed up with a remarkable degree of self-insight the inner conflict of his artist personality by stressing once more, in spite of his stigmatisation as a "degenerate artist", his identity as a "German artist" and at the same time emphatically pointing to the promotion of his art by the liberal Jewish bourgeoisie: "I am a German painter, a vilified painter now. Oh well. I did not look for this; I must bear it, bear it with dignity. I am criticised for having been too German. Too German – ridiculous. Is it shameful to be German? I was born in Germany, achieved fame and sold my work in Germany. I now thank the country by remaining a German. … As an almost 60-year-old I have to say this. Those who appreciated and

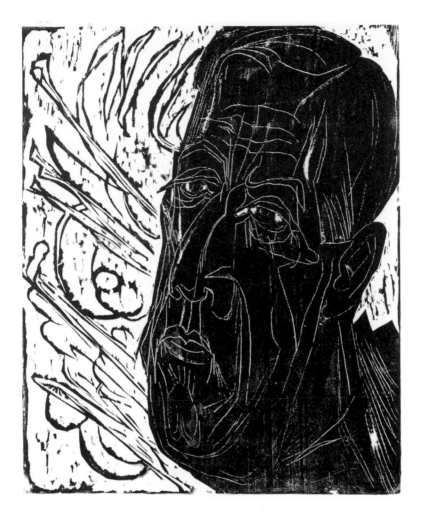

13 *Head of Henry van de Velde, Dark*, 1917
Woodcut, Kirchner Museum Davos

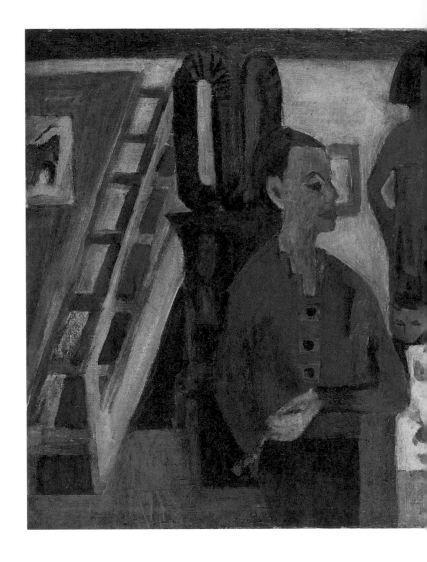

14 *Interior with Painter*, 1920, oil on canvas
Buchheim Museum der Phantasie, Bernried

bought my paintings were Jews. My best and most decent art dealer was a Jew. … No one wanted me to be somehow different from the way I was. They accepted my paintings, appreciated them greatly and had me explain them. It was all spontaneous and fine the way it was."[15]

Written just a few months prior to his suicide, these notes bespeak a profound crisis of identity rather than an ideologically befuddled nationalism. Kirchner, incidentally, stayed strictly clear of the massively emergent local Davos branch of the NSDAP led by Wilhelm Gustloff and avoided any contact with swastika bearers.[16] The individualistic Kirchner loathed military marches and lock step.[17] His fear of the National Socialists who had invaded Austria in March 1938 is therefore also regarded as an important reason why he took his own life on 15 June 1938.

MÉNAGE À TROIS

In 1921 Helene Spengler wrote in a letter to her son-in-law, the philosopher Eberhard Grisebach: "Kirchner was in Zürich today; he was beaming when he came, because he had found a dancer who gave him thousands of ideas for paintings. Mrs. Kirchner was just here when he came and was less excited about the find. He wants to go down one more time next week, because her engagement will soon end! He would like to have her as a guest, but his Suleika [the harem elder] is still quite averse."[18]

The dancer in question was Nina Hard who was born in Brazil in 1899, the daughter of the German plantation owner Engelhardt. She had come to Germany in 1919 to train as a dancer. She achieved some fame in that métier and was internationally successful especially with the German form of modern dance called *Ausdruckstanz*. In the summer of 1921 Nina Hard did actually visit Davos. Numerous nude and portrait photographs Kirchner took of her bear witness to the fascination the self-assured young dancer exerted on the artist. At the end of September, Nina Hard left the Landwasser Valley again, after Kirchner had earlier created the stage decoration for an evening of solo dances at the Zürcher Heilstätte sanatorium in Clavadel. Thus the complicated ménage à trois came to an end.

A now famous 1921 photograph taken by Kirchner shows Nina Hard in front of the entrance of his first residence in Frauenkirch near Davos (39). Also depicted are two life-size sculptures, *Adam* and *Eve*, which flank the

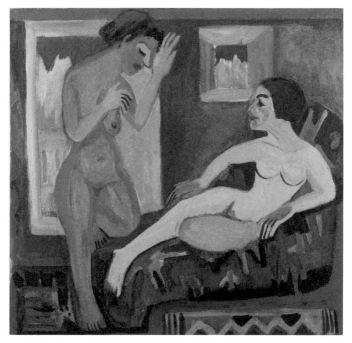

15 *Harem*, 1922, oil on canvas
Private collection

entrance to Kirchner's home as atlas and caryatid, respectively. The instal-
lation shows the seemingly introverted sculpture of *Eva* in half profile,
while *Adam* is positioned frontally. *Eva* receives visitors with her eyes
lowered, while holding a flower underneath her breasts with her right
hand. The appearance of *Adam*, on the other hand, is one of proud virility,
with head held high, an expansive and muscular chest and a firm, pro-
tuberant penis. Overall, the scene evokes an Edenic, Gauguinesque mood
which, if only on account of the eroticism and exoticism of the monumen-
tal wooden sculptures, raises the question of location. The exotic visual
experience is augmented by the back view of Nina Hard who, dressed in
nothing but a grass skirt, has put her hand on *Adam*'s shoulder, while *Eve*
keeps a close eye on this tender gesture. What is presented here is an "eter-
nal triangle"[19] which functions like relationship positioning where the two
sculptures of *Adam* and *Eve* appear to represent the artist couple Ernst

16 *Alpine Life (Triptych)*, 1917–1919, oil on canvas
Kirchner Museum Davos

Ludwig Kirchner and Erna Schilling. At the same time, Kirchner is present as the photographer who created the image and who assigned the pose to Nina Hard.

Nina Hard's intimate closeness to the sculpture of *Adam* visualises wishful thinking on the part of Kirchner, which can be chalked up as yet another contribution to the myth of the erotomanic artist. Far more important, however, is the fact that the scene paradigmatically demonstrates the aspiration of the twentieth-century avant-garde to meld art and life.

RESURRECTION IN THE MOUNTAINS

When Ernst Ludwig Kirchner, traumatised by World War I and in critical condition, arrived in Davos in January of 1917 to receive medical treatment, the Swiss health resort was initially meant to be just a short-term refuge, a place of rescue and recovery. But, in fact, the alpine landscape in Grisons became Kirchner's artistic home. Davos became the place where, as the Dutch art critic Herman Poort dramatically put it, the "miracle of resurrection befell Kirchner."[20] While for many people suffering from tuberculosis Davos was the last stage of their lives, for Kirchner the high valley in the Alps became a place of self-reflection and new beginning.

In the early 1920s, the course was set in Davos for its development into a modern health and sports resort. In 1926, the Davos Verkehrsverein, or Tourist Association, put up posters with the slogan "The Way to Strength

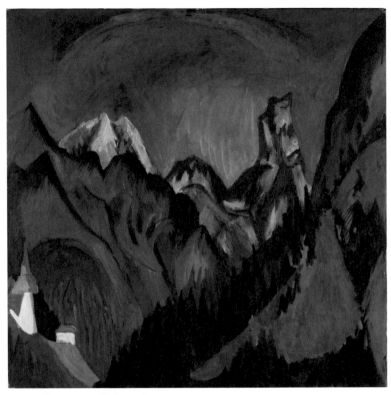

17 *Tinzenhorn – Zügenschlucht near Monstein*, 1919
Oil on canvas, Kirchner Museum Davos

and Health Leads by Davos". Two years earlier, the publication of Thomas
Mann's novel *The Magic Mountain* had caused an uproar with its swan song
to the Belle Époque and its morbid depiction of life in a sanatorium.
After all, the health resort at the time counted fourteen private sanato-
riums, 216 boarding houses, eight public medical facilities and twenty-five
hotels which also accepted sick guests. In the inter-war years the new style
of light-flooded architecture emerged, whose key protagonist was the ar-
chitect Rudolf Gaberel.[21] Early on, eccentric phenomena such as the so-
called *Sonnenbrüder*, or Brethren of the Sun who glided down the slopes
on skis wearing no clothes whatsoever, were also part of the myth of
modern Davos as a city of the sun and the atmospheric trinity of sun, air
and light.[22]

While the young Weimar Republic was bedevilled by street fights, attempted coups and hyperinflation, Kirchner managed to build up a stable life for himself in Switzerland. Regular acquisitions of his paintings by museums and collections and especially the support he received from Carl Hagemann, the major art collector and manager of the I. G. Farben industry conglomerate, ensured that Kirchner made a good living.

Kirchner negotiated the landscape surrounding him through his art. The Swiss Alps replaced the pulsating city life; the thrills of Berlin's nightlife were superseded by monumental mountain panoramas. Kirchner created ideal images, modern in conception, of man's life within nature: mountain scenery, allegorical depictions of the simple life and rural family scenes (16). The new subjects, especially the mountains, the forests and the people living there prompted Kirchner to rethink his art. While his first dwelling place, a hut on Stafelalp, still came about more or less by accident, the house *In den Lärchen* and, later, the *Wildboden* house were undoubtedly chosen deliberately. Kirchner obviously looked for a certain seclusion and close proximity to nature, which is why he settled neither in Frauenkirch nor in Davos. He spent the last two decades of his life in an area of just a few square kilometres – albeit in each case with a magnificent view of the Landwasser Valley and the surrounding mountain ranges. An outstanding example of Kirchner's new landscape painting is *Tinzenhorn* (17). It is a truly visionary painting, as Kirchner recorded in his diary on 10 August 1919: "I dream of a Tinzen painting, at sunset, just the mountain, blue against blue, very plain. Numerous drawings already exist for it."[23] The characteristic form of the mountain reaching for the sky is from then on constantly reiterated in Kirchner's landscape painting as an icon of the Alpine world and its monumentality and a landmark of the Davos countryside. In the painting *Moonrise on Stafelalp* (18) it thus appears very strikingly as a bold emblem of the landscape, while the pink-coloured rising moon seems to set the other mountain ranges into motion. Elongated blue figures bustle about in front of the lodges. Showing obvious similarities to the pictorial cast of Kirchner's Berlin street scenes, they appear like misplaced city dwellers. The painting is a typical transitional work that announces the stylistic migration of forms and colours into the new subject of the Alpine landscape.

Kirchner used the term "hieroglyph", in the sense of a pictorial script or a geometric-abstract graphical symbol, for the transformation of the natural

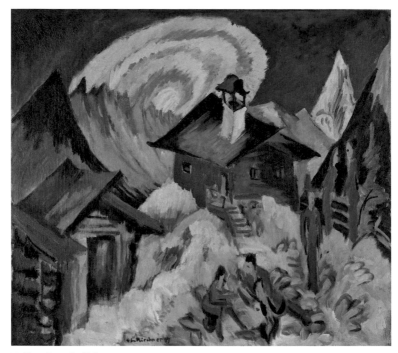

18 *Moonrise on Stafelalp*, 1917
Oil on canvas, Kirchner Museum Davos

form into a subjective, emotional art form. He had the imaginary art critic
Louis de Marsalle state: "Kirchner draws like other people write. His
long-standing practice of capturing everything he sees and experiences in
drawings has made him capable of rendering all that he sees in lines or
forms before his physical, or his mind's, eye. … Just as in letters of sensi-
tive people the writing itself is already indicative of the writer's state of
mind, these drawings are in their lines an indication of the depicted scene,
similar to the recordings on the rotating drum of a manometer. Emotion
forms ever new hieroglyphs which separate from what, at first, seems to be
a chaotic mass of lines, thereby becoming almost geometric signs."[24] The
comparison to the recordings of a mechanical pressure gauge is telling, for
the technological metaphor serves to conflate "objective" precision and
immediate, subjective experience. The drawing artist thus appears as the
seismographer of his living environment, as he records, expresses and
communicates to his "readers" what moves and stirs him. Inner and outer

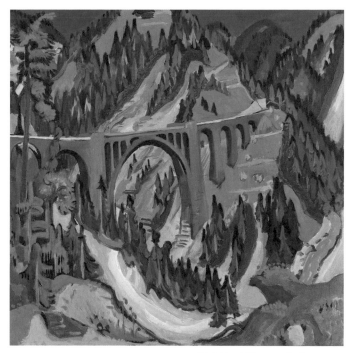

19 *Bridge at Wiesen*, 1926, oil on canvas
Kirchner Museum Davos

movement correspond directly to one another; writing or drawing is invariably also an expression of the artist's state of mind.

Kirchner was most certainly not a great hiker or mountaineer who took on strenuous physical activities or climbed craggy peaks. He did not create a high alpine outdoor studio for himself like Giovanni Segantini, nor did he let his paintings cure in the open air when there was frost or snow, as did Edvard Munch. Instead, Kirchner strolled through the landscape and occasionally into "urban" Davos where he would spend time drawing guests at Café Schneider. Other than that he seems to have cherished the panorama view of the sublime Alpine world and orbited his studio, as it were. Apart from occasional sallies into the Sertig Valley, to the Amselfluh, to Clavadel, Monstein or Wiesen, there is no evidence of long hikes.

Among Kirchner's last major mountainscapes is the painting *Bridge near Wiesen* (19), which is no longer a mountainscape in the true sense, as it shows, rather, a mountain landscape controlled by man and technology.

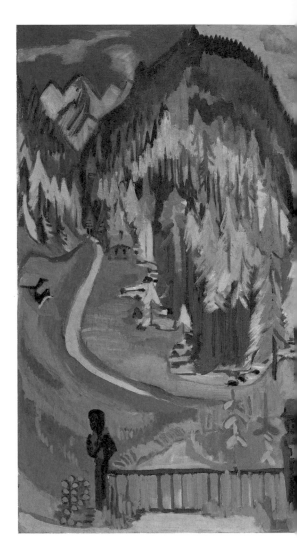

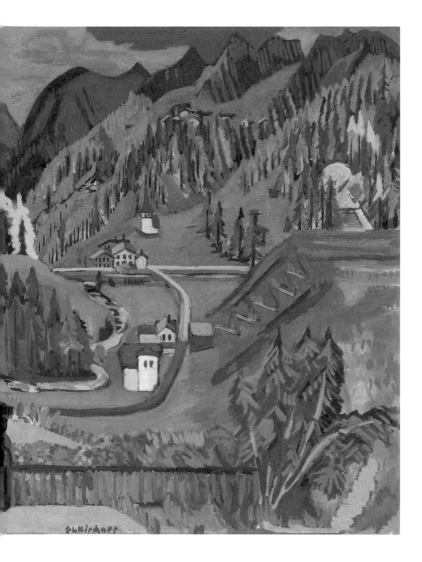

20 *Sertig Valley in Autumn*, 1925–26, oil on canvas
Kirchner Museum Davos

The overflowing colourfulness of nature contrasts with the bold sweep and monolithic solidity of the bridge which at the same time connects and cuts up the landscape.

The bridge was beyond the usual scope a symbol of progress, because in Grisons automobile traffic was allowed only from 1925 on. Consequently, the Rhaetian Railway was the most modern means of transportation in the mountain canton which automobiles (until said transport policy turnaround) were allowed to cross only with the engine turned off and towed by horse and cart.

The major landscape painting *Sertig Valley in Autumn* (20) shows the panorama of Landwasser Valley seemingly stretched into the surface with a wide-angle lens. The world of Kirchner, which the artist saw every day from the terrace of his Wildboden house, is presented as if at a glance. By contrast, the iconic painting *Davos with Church; Davos in Summer* (21), which offers a view of the Alpine village from the north, is the result of an artistic condensation that combines top and bottom view. Beyond the spa gardens in the foreground rises the compressed town with its already characteristic flat-roof architecture. The Tinzenhorn, which is moved extremely close in the background, and the Davos church steeple accentuate the vertical landscape structure.

I AM ANOTHER

When Ernst Ludwig Kirchner set off from Switzerland to visit Germany at the end of 1925, he noted in his diary: "Now I am across the border for the first time in nine years. Do I have a country that is home to me? No. Outsider here, outsider there: no one wants me."[25] Significantly, this realisation of rootlessness occurred at the very time Kirchner was trying to connect to the international avant-garde. In the autumn of 1925 he had gained an overview of the current situation in the *International Art Exhibition* at the Kunsthaus Zürich and found that Pablo Picasso was the "most extraordinary and best"[26] of the exhibiting artists. It appears, however, that Kirchner's particular interest in Picasso was promoted by the latter's turn to Surrealism. The principle of deformation of the human form and physiognomy cultivated by Picasso was a further stage in the development of his stylistic repertoire and at the same time a contribution to the "amoeba-

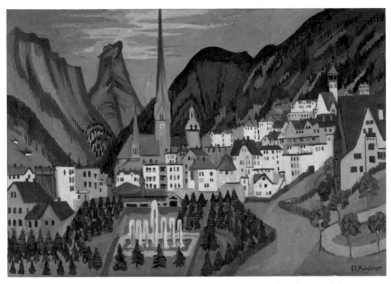

21 *Davos with Church; Davos in Summer,* 1925
Oil on canvas, Kirchner Museum Davos

like forms"[27] that were part of the inventory of Surrealism through the
1920s. Kirchner continued to follow Picasso's career closely and compared
it to his own artistic development: "Picasso only now arrives at similar
results indirectly, by way of Cubism and Classicism. ... I am arriving more
and more at clarity and purpose of my work. ... It is the new surface paint-
ing which really does employ all new things, even parts of perspective,
within the surface."[28]

In the following years Kirchner sought to realise his idea of a universally
understandable, allegorical art based on the human figure. The artist who
conceived of his name as a *Fabrikmarke,*[29] or trademark, desperately wanted
to get rid of the Expressionist label. Expressive spontaneity and direct rep-
resentation of an immediate impression made way for a monumental
decorative exaltation of general emotions and states, such as joie de vivre,
sensuality, love, fear and agitation. His aspiration for a symbolic and alle-
gorical form of painting manifested itself in dynamic lines, bold physio-
gnomic deformations of the human figure and arabesque-like forms. His
artistic agenda consisted in reducing the representation of the visible, yet

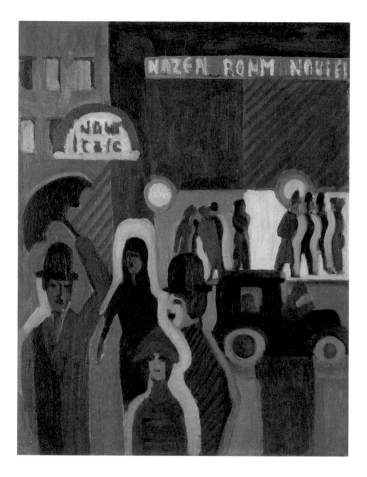

22 *Department Store in the Rain,* 1926–27
Oil on canvas, Kirchner Museum Davos

at the same time holding on to the idea of the recognisability of what is depicted.

Aspects of light and shade became a subject of intense study for Kirchner and his visits to Frankfurt, Dresden and Berlin in the winter of 1925–26, in particular, produced a series of street scenes focusing on the city illuminated by artificial light and neon signs. Although Kirchner was interested in the simultaneous depiction of consecutive events, this second generation of street scenes features a more linear, constructed image composition and an emphasis on colour shadows providing passers-by with an aura. In the painting *Department Store in the Rain* (22) the pedestrians rush and hurry rather than stroll. The dawdler in front of the window displays is no more than a busy shadow of the *flâneur*, who had once demonstratively displayed slowness as symbolic capital. The painting *Woman Walking across the Street at Night; Night Woman* (23) establishes a connection to the erotically charged street scenes of the pre-war years. The metropolitan simultaneity of different events is arranged here as a juxtaposition and superimposition within the surface, as the woman of the night – shaded by the silhouette of a male head – walks the polychrome stage of the city. As

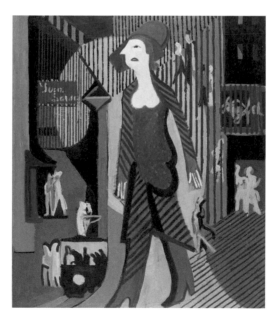

23 *Woman Walking across the Street at Night; Night Woman*, 1928–29
Oil on canvas
Private collection

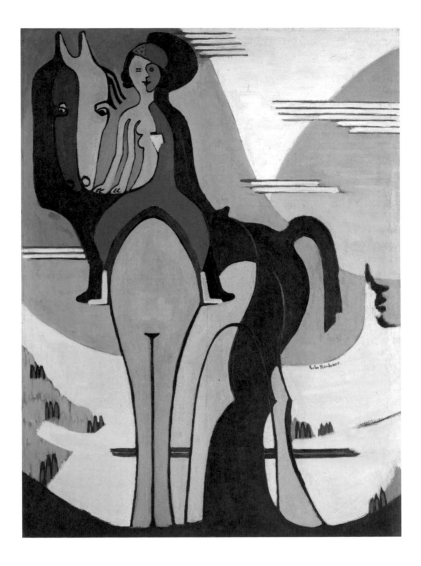

24 *The Rider*, 1931–32, oil on canvas
Kirchner Museum Davos

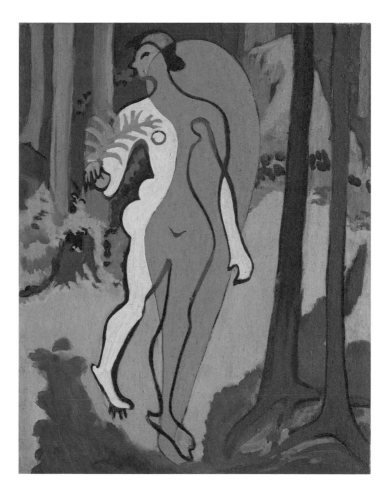

25 *Nude in Orange and Yellow,* 1929–30
Oil on canvas, Kirchner Museum Davos

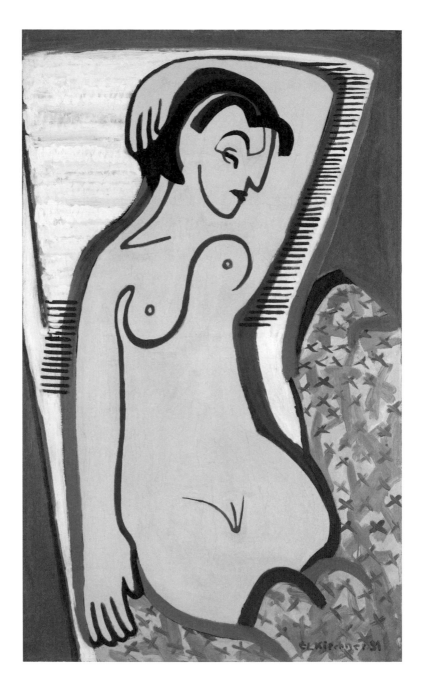

Kirchner commented in the catalogue of the 1933 exhibition in Bern: "The painting condenses the impressions of a big-city street at night (Berlin): the street car that is just pulling away from a sign pole and, next to it, the KDW department store with couples and then the coloured beams entering the picture from different light sources. The bright centre outlines the head of a passing observer. The woman's face in profile en face."[30] Assembling no fewer than 105 paintings, the catalogue includes explanatory texts by Kirchner on almost all works. Prime examples of Kirchner's new style are the paintings *The Rider* (24) and *Recumbent Nude* (26), which were also included in the exhibition in Bern. The conception of the horsewoman traces back to several photographic subjects which Kirchner synthesised in the painting by superimposing three views within the surface. Without any perspectival means the painting envisions the ability to view horse and rider from all sides as pure surface. The reclining female nude, in turn, is conceived as a same-colour surface: the degree of abstraction is taken even further in this painting through the use of hatching and curved letter-like lines. Here Kirchner literally demonstrates the legibility of his painting for which he claimed absolute uniqueness: "My work is different; it involves recreating an inner image with abstract forms, a concentration, creating that which is seen inwardly in the experience."[31]

The interplay of colour rhythm and repetition of linear forms is evident in the painting *Pair of Acrobats – Sculpture* (27) which presents a wooden sculpture created by Kirchner as a stage event. Illuminated by two light sources, the balancing act, by dint of the shadows it casts, forms a triple ornamental roundelay of acrobats, which convincingly conveys both utmost tension and movement.

The exhibition at the Bern Kunsthalle in the spring of 1933 was the largest retrospective of Kirchner to date which, moreover, placed the artist's most recent works in the overall context of his work since 1905. Kirchner had led the young Kunsthalle director Max Huggler to believe that he had an as yet unpublished text by his recently deceased friend Louis de Marsalle which he would like to have included in the catalogue accompanying the exhibition. In his article, de Marsalle once more reviewed the main stages

26 *Recumbent Nude,* 1931
Oil on canvas, Kirchner Museum Davos

of Kirchner's artistic development. It ends with a hymn to the uniqueness and originality of Kirchner's work: "Around 1926 Kirchner's talent again gathers itself for a new achievement by taking all he had accomplished up to then and producing visionary compositions in a technique which in its simplicity approaches that of the early work. … With his new works Kirchner thus aligns contemporary German art with the international modern sense of style using nothing but original means that for now are his alone. In doing so, he loses neither originality nor power; on the contrary, his work of today is the logical consequence of his entire work over thirty years and true of him are the words of Nietzsche: "You should propagate yourself not only forward, but upward.""[32]

JOURNEY AROUND THE STUDIO

After 1935, Ernst Ludwig Kirchner created several paintings that can be seen as taking stock of his life and offering a panorama of his work. The painting *Mountain Studio* (28) is regarded as a prime example of such an allegory of life, just as the view of the interior of the Wildboden house, in which Kirchner lived with Erna Schilling from 1923 on, summarily visualises the melding of life and art. The perspectively receding walls with their distinct zig-zag pattern appear like a folding screen which presents crucial stages of the artist's life and work in a careful arrangement. As in Kirchner's street scenes, the triangle emerges as the dominant basic geometric form. By contrast, the circle in the form of the target symbolises Kirchner's lifelong fascination with archery and dynamic motion sequences. The truncated painting *Balcony Scene* (29) from 1935 refers to Kirchner's physician, Dr. Frédéric Bauer, while the wooden sculpture featuring a peasant and a cow appears to be a tribute to the simple life in the mountains. The relationship between man and nature is present through the open door which offers a view of the mountains. In the middle, as if on a peep-show stage, the artist presents himself partly hidden by the profile of his companion; the central image at the rear of the stage, however, is the exemplary painting *Nude with Red Hair* from 1925–26.

Life and art have turned into an interior portrait. Everything is allegory and the world is a parlour. We are reminded of the fear-informed childhood of Danish philosopher Sören Kierkegaard, who had to walk across

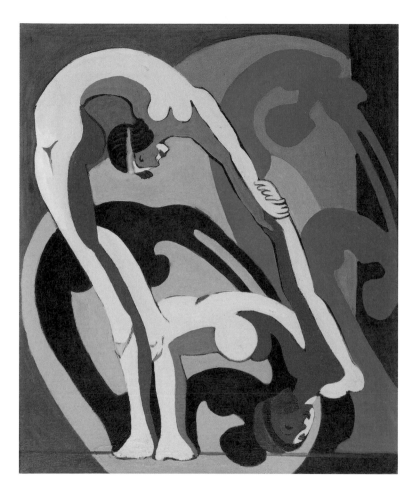

27 *Pair of Acrobats – Sculpture*, 1932–33
Oil on canvas, Kirchner Museum Davos

28 *Mountain Studio*, 1937
Oil on canvas, Kirchner Museum Davos

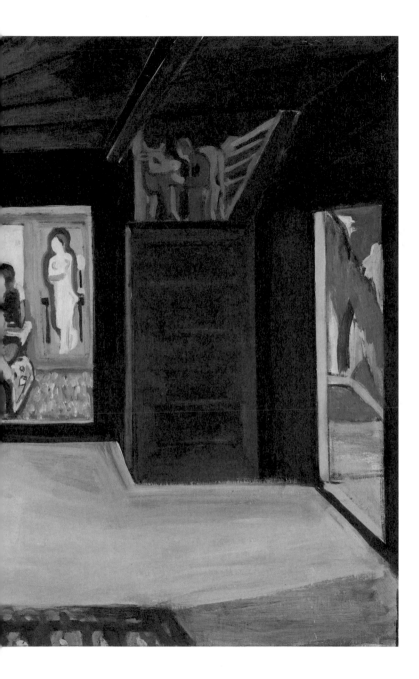

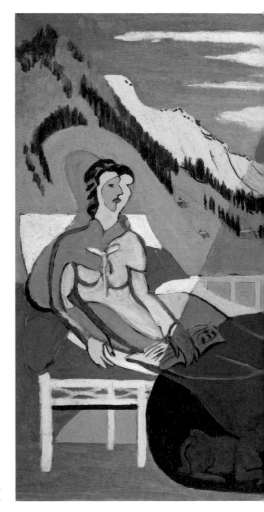

29 *Balcony Scene*, 1935
Oil on canvas
Kirchner Museum Davos

the wooden floor of his own home to imaginary destinations with his father. The father told his son about the world outside, yet the son was not allowed to set foot in it, as his father was terrified of the harm that could befall him.

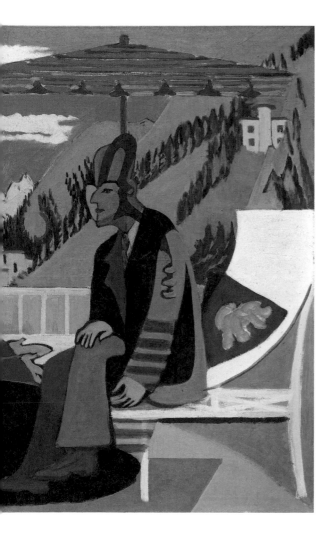

THORSTEN SADOWSKY *studied History, Philosophy and Ethnology at the University of Hamburg. After completing his doctorate and teaching assignments at the Copenhagen Polytechnic, he held executive positions at various art museums, including the Kunsthal Aarhus in Denmark and the Museum Kunst der Westküste on the North Sea island Föhr. Since April 2013 he has been the Director of the Kirchner Museum Davos. He has authored numerous publications on Classical Modernism and contemporary art.*

1 Georg Simmel, "On Art Exhibitions" (1890), trans. Austin Harrington, in: *Theory, Culture & Sociology*, 32/1 (2015), pp. 87–92, here p. 88.

2 Ibid., p. 89.

3 See Lothar Müller, "Modernität, Nervosität und Sachlichkeit. Das Berlin der Jahrhundertwende als Hauptstadt der 'neuen Zeit'", in: *Mythos Berlin. Zur Wahrnehmungsgeschichte einer industriellen Metropole* (Berlin, 1987), pp. 79–92, here pp. 85 ff. In his "Berlin Chronicle" the philosopher Walter Benjamin reported that the rhyme *Eile nie und haste nie / dann haste nie / Neurasthenie* (Loitering at the rear, / you never need fear / neurasthenia) was on everyone's lips. See Walter Benjamin, "A Berlin Chronicle", in: *Walter Benjamin: Selected Writings*, vol. 2, part 2, 1931–1934 (Cambridge, MA, and London, 2005), pp. 595–637, here p. 603. For a detailed discussion of the topic see Joachim Radkau, *Das Zeitalter der Nervosität. Deutschland zwischen Bismarck und Hitler* (Munich 1998).

4 See Gottfried Korff, "Die Stadt aber ist der Mensch …", in Gottfried Korff and Reinhard Rürup (eds.), *Berlin, Berlin. Die Ausstellung zur Geschichte der Stadt*, exh. cat. Martin-Gropius-Bau Berlin (Berlin 1987), pp. 643–63; Gottfried Korff, "Mentalität und Kommunikation in der Großstadt. Berliner Notizen zur inneren Urbanisierung", in: Theodor Kohlmann et al. (eds.), *Großstadt. Aspekte empirischer Kulturforschung* (Berlin 1985), pp. 343–61.

5 Georg Simmel, "The Metropolis and Mental Life" (1903), in *Simmel on Culture: Selected Writings*, ed. by David Frisby and Mike Featherstone (London 1997), pp. 174–86, here pp. 178 f.

6 Ibid., p. 185. For the different manifestations of the flâneur in Berlin see Harald Neumeyer, *Der Flaneur. Konzeptionen der Moderne* (Würzburg 1999), pp. 144 ff., 295 ff.

7 Sebastian Lemke, "Zur Psychopathologie des bildenden Künstlers Ernst Ludwig Kirchner", in: *Schweizer Archiv für Neurologie und Psychiatrie* 5 (1999), pp. 248–54, here pp. 251 f.

8 Thomas Röske, "Der Lebenskamerad – Das Verhältnis Ernst Ludwig Kirchners zu Erna Schilling", in: Roland Scotti (ed.), *magazin IV: Erna und Ernst Ludwig Kirchner – Ein Künstlerpaar* (Davos 2003), pp. 11–34.

9 Lothar Grisebach, *Ernst Ludwig Kirchners Davoser Tagebuch. Eine Darstellung des Malers und eine Sammlung seiner Schriften*. New edition revised by Lucius Grisebach (Ostfildern 1997), p. 29.

10 Bettina Gockel, "Utopie und Fotografie. Ernst Ludwig Kirchners Weltbild und seine künstlerische Selbstbestimmung nach 1918", in: Nanni Baltzer and Wolfgang Kersten (eds.), *Weltenbilder. Studies in Theory and History of Photography*, vol. 1 (Berlin 2011), pp. 51–68; Thorsten Sadowsky, "Selbstbeobachtung und Rauchzeichen. Zur Rolle der Fotografie im Werk Ernst Ludwig Kirchners", in: Thorsten Sadowsky (ed.), *Ernst Ludwig Kirchner. Der Künstler als Fotograf*, exh. cat. Kirchner Museum Davos (Heidelberg/Berlin 2016), pp. 14–25.

11 Matthias M. Weber, "'Es ist frei von schädlichen Nebenwirkungen …' Ernst Ludwig Kirchners Abhängigkeit vom Opiat-Analgetikum Eudokal", in: Hans Delfs and Roland Scotti (eds.), *magazin V: Frédéric Bauer* (Davos 2004), pp. 39–50, here pp. 46 f.

12 For Kirchner's late work see Hyun Ae Lee, *"Aber ich stelle doch nochmals einen neuen Kirchner auf". Ernst Ludwig Kirchners Davoser Spätwerk* (Münster 2008). Changes in Kirchner's style and life are discussed in detail based on his representations of women by Hyang-Sook Kim, *Die Frauendarstellungen im Werk von Ernst Ludwig Kirchner. Verborgene Selbstbekenntnisse des Malers* (Marburg 2002).

13 See Anita Beloubek-Hammer, "Ernst Ludwig Kirchner, ein 'unruhiger Lebenssucher'. Die Weltsicht des Künstlers im Spiegel seiner Graphik", in: Anita Beloubek-Hammer (ed.), *Ernst Ludwig Kirchner. Ekstase des Sehens und gestaltende Form. Kolloquium anlässlich der Ausstellung Ernst Ludwig Kirchner. Erstes Sehen. Das Werk im Berliner Kupferstichkabinett* (Berlin 2007), pp. 119–45.

14 See Felix Krämer, "Im Widerspruch. Ernst Ludwig Kirchner", in: Felix Krämer (ed.), *Ernst Ludwig Kirchner. Retrospektive*, exh. cat. Städel Museum, Frankfurt am Main (Ostfildern 2010), pp. 13–31; Wolfgang Henze, "Bedeutung und Funktion der Zeichnung im Werk von Ernst Ludwig Kirchner", in: Beloubek-Hammer 2007 (see note 13), pp. 22–37.

15 Quoted in Eberhard W. Kornfeld, *Ernst Ludwig Kirchner. Nachzeichnung seines Lebens* (Bern 1979), pp. 319 f.

16 For the role of Davos as a stronghold of National-Socialism in Switzerland see Urs Gredig, *Gastfeindschaft. Der Kurort Davos zwischen nationalsozialistischer Bedrohung und lokalem Widerstand 1933–1948*, 2nd ed. (Davos 2008), pp. 25 ff.

17 The contradictions in Kirchner's personality and his alleged anti-Semitism have been thoroughly analysed in a mentality study by Christian Saehrendt, *Ernst Ludwig Kirchner. Bohème-Identität und nationale Sendung* (Frankfurt am Main 2003).

18 Helene Spengler in a letter to Eberhard Grisebach dated 14 May 1921, in *'Ich bin den friedlichen Bürgern zu modern'. Aus Eberhard Grisebachs Briefwechsel mit seinen Malerfreunden*, ed. by the Kirchner Museum Davos, compiled by Lothar Grisebach, revised and annotated by Lucius Grisebach (Zürich 2000), p. 215.

19 See Henrik Ibsen, "Hedda Gabler", trans. Kenneth McLeish (London 1995).

20 Herman Poort, "E.L. Kirchner", in *Das Kunstblatt*, 9 (1926), pp. 331–350, here p. 335.

21 See Franco Item (ed.), *Davos – zwischen Bergzauber und Zauberberg. Kurort, Sportort, Kongress- und Forschungsplatz 1865–2015* (Zürich 2015), pp. 47, 114f.; Christof Kübler, "Architektur als Kur", in ibid., pp. 196–220.

22 See *Sport Schweiz, Suisse, Svizzera. Das offizielle Dokumentationswerk des Schweizerischen Landesverbandes für Sport*, ed. on behalf of the Stiftung Schweizer Sporthilfe, 2 vols., vol. 2: 1881–1912 (Baar 1981), p. 42.

23 Grisebach 1997 (see note 9), p. 44.

24 Louis de Marsalle, "Zeichnungen von E. L. Kirchner" (1920), in Grisebach 1997 (see note 9), pp. 221–224, pp. 221, 223. See also Thomas Röske, "'Kirchner zeichnet wie andere Menschen schreiben'. Ernst Ludwig Kirchners Kunsttheorie und ihre Quellen", in Brigitte Schad (ed.), *Ernst Ludwig Kirchner. Leben ist Bewegung*, exh. cat. Galerie der Stadt Aschaffenburg/Landesmuseum Odenburg (Cologne 1999), pp. 70–86; Joachim Jäger, "Strichmuster, Luftschatten, Hieroglyphen", in Joachim Jäger (ed.), *Ernst Ludwig Kirchner: Hieroglyphen*, exh. cat. Nationalgalerie, Staatliche Museen zu Berlin (Berlin 2016), pp. 32–51.

25 Grisebach 1997 (see note 9), p. 112.

26 Ibid., p. 92.

27 Werner Spies (ed.), *Surrealismus 1919–1944. Dali, Max Ernst, Magritte, Miró, Picasso…*, exh. cat. K20 Kunstsammlung Nordrhein-Westfalen (Düsseldorf 2002), pp. 34f.

28 Grisebach 1997 (see note 9), p. 154.

29 Ernst Ludwig Kirchner in a letter to Georg Schmidt dated 26 August 1925, in Hans Delfs (ed.), *Ernst Ludwig Kirchner. Der gesamte Briefwechsel*, 4 vols. (Zürich, 2010), no. 1311.

30 *Ausstellung Ernst Ludwig Kirchner*, with texts by Max Huggler and Louis de Marsalle, exh. cat. Kunsthalle Bern (Bern 1933), p. 31.

31 Grisebach 1997 (see note 9), p. 209.

32 Kirchner 1933 (see note 30), pp. 14–16, here p. 16.

30 Ernst Ludwig Kirchner, 1913–14

BIOGRAPHY

Ernst Ludwig Kirchner
1880 – 1938

1880 Ernst Ludwig Kirchner is born on 6 May in Aschaffenburg; he is the first son of Ernst und Maria Elise Kirchner, née Franke. His father is a chemist and works in the paper industry. His two brothers, Hans Walter and Ulrich, are born in 1882 and 1888.

1886-87 The family moves to Frankfurt am Main; in the following year they move to Perlen near Lucerne. Ernst Ludwig is sent to school there.

1890 Ernst Kirchner is appointed Professor of Paper Science at the Technical Institute and Industrial Academy in Chemnitz. The family joins him there. Ernst Ludwig attends grammar school.

1901/02 After graduating from high school, Kirchner starts studying architecture at the Polytechnic in Dresden. There he meets Fritz Bleyl, a fellow student; the two quickly become close friends. Apart from his studies, Kirchner devotes himself to drawing and watercolour painting.

1903/04 After receiving his intermediate diploma, Kirchner studies architecture for a semester at the Royal Bavarian Polytechnic in Munich. At the same time he attends the so-called Debschitz-Schule, a reform-oriented private art school.

1904 He continues his architecture studies in Dresden. He creates his first oil paintings and woodcuts. Together with Bleyl, Kirchner discovers the inspiring lake country around Baroque Moritzburg Castle near Dresden. He and fellow student Erich Heckel become friends.

1905 Kirchner meets Karl Schmidt who will go by the name Schmidt-Rottluff. The friends paint and draw together, creating the "quarter-hour nudes", drawings of nude models in the studio or out in nature. Kirchner, Heckel, Bleyl and Schmidt-Rottluff found the artists' group "Brücke" on 7 June. Kirchner graduates and obtains his diploma in engineering. In September he takes over Heckel's studio at 60 Berliner Strasse. In November the "Brücke" group presents its first exhibition at Kunsthandlung P. H. Beyer & Sohn in Leipzig.

1906-07 The "Brücke" drafts its programme which is published, among other things, as a woodcut by Kirchner (see p. 70). Emil Nolde, Max Pechstein and Cuno Amiet join the group. From the end of the year until January 1907 a major exhibition of the artists' group is held at the showrooms of the lamp factory of Karl Max Seifert in Dresden. Kirchner participates for the first time in an exhibition of the "Berlin Secession". In September, the "Brücke" holds an exhibition at Kunstsalon Emil Richter in Dresden, for which Kirchner produces the poster lithograph.

1908 In the summer Kirchner travels together with Hans Frisch and his sister Emy (who will later marry Karl Schmidt-Rottluff) to the island of Fehmarn in the Baltic Sea. Emy is a trained photographer and Kirchner learns photography from her. He creates his first circus and cabaret paintings.

1909 In June a major "Brücke" exhibition opens at Kunstsalon Richter in Dresden. In the summer Kirchner and Heckel travel to the Moritzburg Lakes to work. Eight-year-old Fränzi Fehrmann becomes the artist group's most important model. Kirchner meets Doris Grosse ("Dodo"), a milliner from Dresden, who is his model and lover until his move to Berlin in 1911.

1910 Kirchner visits Pechstein in Berlin; he creates his first paintings of Berlin cityscapes. Like his fellow "Brücke" members, Kirchner joins the "Neue Secession". The painter Otto Mueller joins the "Brücke". Together with Heckel and Pechstein, Kirchner spends two summer months in Moritzburg. In September, Galerie Arnold in Dresden presents the exhibition *Künstlergruppe Brücke*. In October, Kirchner meets art collector Gustav Schiefler and art historian Rosa Schapire in Hamburg. Inspired by his visits to the Dresden Museum of Ethnology, Kirchner creates his first wooden sculptures.

1911 In February–March, the Jena Kunstverein mounts a major "Brücke" exhibition. Together with Heckel, Kirchner travels to the Moritzburg lakes for the last time. In October, he moves to the Wilmersdorf district of Berlin and rents a studio apartment at 14 Durlacher Strasse. Together with Pechstein, who lives next door, he founds the MUIM Institute (Moderner Unterricht in Malerei, or Modern Instruction in Painting), whose only

students are Hans Gewecke and Werner Gothein. The private art school is liquidated in 1912. Kirchner makes important contacts in Berlin, including the writers Wilhelm Simon Guttmann, Georg Heym, Kurt Hiller and Jacob van Hoddis. Kirchner participates in the fourth exhibition of the "Neue Secession", which also shows works by Wassily Kandinsky and Franz Marc. In the period from July 1911 until March 1912, Herwarth Walden publishes a total of ten woodcuts by Kirchner in his magazine *Der Sturm*.

1912 Kirchner participates in the "Blauer Reiter" exhibition at Galerie Hans Goltz in Munich in February. In April the first "Brücke" exhibition in Berlin is held at Kunstsalon Fritz Gurlitt. Erich Heckel and Kirchner are commissioned to decorate the chapel at the Cologne "Sonderbund" exhibition. Kirchner meets Erna Schilling and her sister Gerda who at first becomes his girlfriend. He spends the summer with Erna on Fehmarn and she becomes his new partner and will remain his life companion until his death. At the end of the year the poet and psychiatrist Alfred Döblin visits Kirchner at his studio.

1913 Kirchner participates in the famous *International Exhibition of Modern Art*, the so-called *Armory Show*, in New York, which is the first major exhibition of modern art in the U.S. He writes the *Chronik KG Brücke* (Chronicle of the Brücke Artists' Group); his one-sided portrayal leads to a dispute which causes the artists' group to dissolve on 27 May. He illustrates Döblin's novella *Das Stiftsfräulein und der Tod* (The Canoness and Death) which is published in 1914. In October Kirchner moves into a studio at 45 Körnerstrasse in Berlin-Friedenau, designing some of its furnishings himself. The Museum Folkwang in Hagen and Galerie Gurlitt in Berlin devote solo exhibitions to Kirchner's work.

1914 The Jena Kunstverein presents a solo exhibition from February until March. Kirchner maintains friendly relations with the archaeologist Botho Graef and the philosopher Eberhard Grisebach, among others. In the summer Kirchner and Erna Schilling go to Fehmarn for the last time; the outbreak of war forces them to cut short their stay. In addition to numerous street scenes, Kirchner creates his first self-portraits which reflect his growing anguish about his impending enlistment. His consumption of absinthe increases steadily.

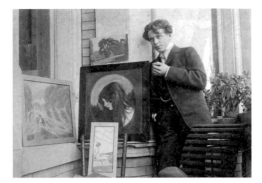

31 Ernst Ludwig Kirchner with early paintings, c. 1902

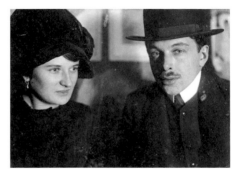

32 Doris Grosse (Dodo) and Ernst Ludwig Kirchner, c. 1910

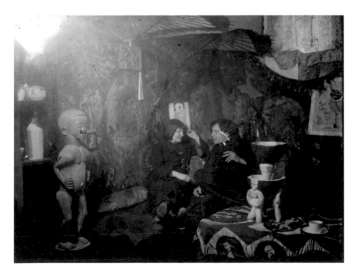

33 Erna Schilling and Ernst Ludwig Kirchner in the studio in Berlin-Wilmersdorf, c. 1912–14

1915 Knowing that he will not be able to avoid being drafted, Kirchner voluntarily reports for military service in July, hoping this will allow him to choose at least the branch of the army. He is assigned to the Field Artillery in Halle an der Saale. As early as September, he is discharged from service due to mental illness and in December he is admitted to Dr. Kohnstamm's sanatorium in Königstein im Taunus with the diagnosis "alcoholism, addiction to sleeping pills and morphine". His self-portraits from this period – *Self-Portrait as Soldier* and *The Drinker* – attest to his despair (9, 10). Through Graef he meets Ludwig Schames, the Frankfurt art dealer, and the industrial manager, Dr. Carl Hagemann, who becomes one of Kirchner's main collectors.

1916 In spite of several stays at the sanatoriums of Dr. Kohnstamm in Königstein and Dr. Edel in Berlin-Charlottenburg, Kirchner's health remains unstable.

1917 Kirchner stays in Davos, Switzerland, for the first time from 19 January until 4 February in order to undergo treatment. There he makes the acquaintance of the family of the physician Lucius Spengler and his wife, Helene. At the end of February a Kirchner exhibition opens at the Jena Kunstverein. Botho Graef, Kirchner's friend and mentor, dies on 9 April. In early May, Kirchner travels to Davos again. Together with a carer he spends the summer at the Rüesch-Hütte, a hut on Stafelalp near Davos. In spite of temporary symptoms of paralysis and disturbances of consciousness, Kirchner creates numerous woodcuts on the subject of rural life. From September onwards, Kirchner stays at Dr. Ludwig Binswanger's Bellevue Sanatorium in Kreuzlingen on the Swiss shore of Lake Constance. Erna Schilling remains in Berlin and attends to Kirchner's business affairs.

1918 In March–April, Kirchner participates in an exhibition at the Kunsthaus Zürich. He establishes the Botho Graef Foundation for the Jena Kunstverein in memory of Botho Graef and personally contributes more than 250 prints and drawings as a gift. In early July, Kirchner is discharged from the Bellevue Sanatorium and he moves to Stafelalp again. From 20 September onwards, Kirchner lives in a house called "In den Lärchen" in Davos-Frauenkirch, which he furnishes with carved furniture and

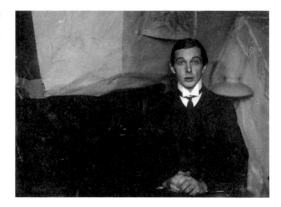

34 Self-portrait in the studio apartment in Berlin-Friedenau, 1913–15

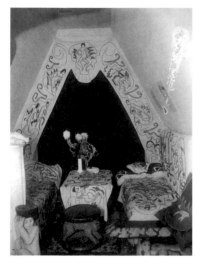

35 Garret in the studio apartment in Berlin-Friedenau, 1914–15

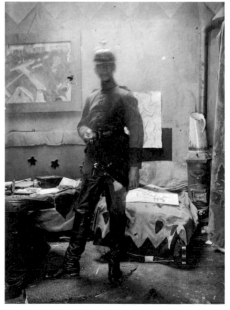

36 *Self-Portrait as a Soldier* in the studio at 45 Körnerstrasse in Berlin-Friedenau, 1915

sculptures. He paints a series of alpine landscapes of ecstatic colourfulness, which are among the most important works of those years. In the autumn he draws up his "Painter's Credo". The end of the war and the continuing care of Dr. Spengler have a positive effect on Kirchner's health.

1919 Erna Schilling sends Kirchner's works and his printing press from Berlin to Frauenkirch to prepare for the liquidation of the studio. Kirchner starts to restore partially, as well as to paint over, his early paintings. The most important Kirchner exhibition to date is held in February and March at Galerie Ludwig Schames in Frankfurt am Main. Kirchner starts to keep a diary from 5 July; he spends the summer on Stafelalp.

1920 Kirchner's work is presented at the beginning of the year in a major exhibition of prints at Schames in Frankfurt. Kirchner uses the pen name Louis de Marsalle for the first time for an article in the magazine *Genius*, in order to provide an "objective" account of his work and artistic development. Five more articles by Louis de Marsalle subsequently appear. Until his death Kirchner will not divulge the true identity of this alter ego.

1921 A Kirchner exhibition opens at the Kronprinzen-Palais in Berlin. He meets Nina Hard, a dancer, who visits him in Davos in the summer and sits for numerous paintings. Erna Schilling now lives permanently with Kirchner in Switzerland.

1922 In January an exhibition of Swiss works, *Schweizer Arbeiten von E.L. Kirchner 1916–1920*, is on view at Galerie Ludwig Schames in Frankfurt. Kirchner makes the acquaintance of Davos physician Dr. Frédéric Bauer. He finalises the liquidation of his studio in Berlin.

1923 After the death of Dr. Lucius Spengler, Kirchner reclaims his patient record, but it turns out to be untraceable, which leads to a rift with the Spengler family. From now on Kirchner is treated medically by Dr. Bauer. In June a solo exhibition is presented at the Basel Kunsthalle. In October Kirchner and Erna Schilling move into the farmhouse "Auf dem Wildboden" in Davos-Frauenkirch. At the end of the year, two solo exhibitions in Berlin present drawings and watercolours (at Goldschmidt & Wallerstein) and paintings (at Paul Cassirer).

37 *Peasant Dance* upstairs in the house "In den Lärchen" with self-portrait on the left, 1919–20

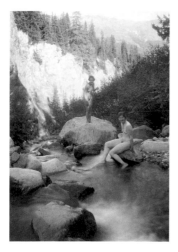

38 Nina Hard and Erna Schilling bathing in the Suzibach ravine, 1921

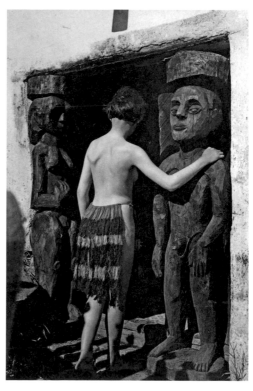

39 Nina Hard in front of the entrance to the house "In den Lärchen", 1921

1924 In June–July the Winterthur Kunstverein presents a large solo exhibition which creates a public scandal.

1925 In his diary Kirchner writes the essay *Das Werk* (The Work), in which he outlines his artistic career. He is awarded the *Preis der Republik* for his work *Junkerboden* at the spring exhibition of the Prussian Academy of Arts in Berlin. At the end of the year Kirchner travels to Germany again for the first time.

1926 After stops in Frankfurt am Main, Chemnitz, Berlin and Dresden where Kirchner's drawings include the Expressionist dancers Mary Wigman and Gret Palucca, he returns to Switzerland. His works are presented in several solo exhibitions in Berlin, Cologne, Dresden and Munich. The Davos Art Society presents the exhibition *Kirchner 10 Jahre in Davos*. The first volume of Gustav Schiefler's *Die Graphik Ernst Ludwig Kirchners* and Will Grohmann's monograph *Das Werk Ernst Ludwig Kirchners* are published.

1927 Kirchner discusses the possibility of painting murals for the museum's central hall with the director of the newly built Museum Folkwang in Essen, Dr. Ernst Gosebruch. This project will preoccupy him during the following years. Solo exhibitions are held at the Wiesbaden Kunstverein and at Kunstsalon Fides in Dresden, and a comprehensive survey of his graphic work is shown at Galerie Aktuaryus in Zürich. Kirchner is increasingly interested in contemporary theories of painting.

1928 Kirchner's painting *Schlittenfahrt* (Sleigh Ride) is exhibited in the German pavilion at the Venice Biennale. The Nationalgalerie in Berlin acquires Kirchner's 1925 painting *Eine Künstlergruppe: Die Brücke* (An Artists' Group: Die Brücke). Kirchner works on designs for the Folkwang Museum in Essen.

1929 As in the previous year, Erna Schilling travels to Berlin on several occasions. In April–May Kirchner takes up correspondence with the painter and Bauhaus student Fritz Winter, who visits him in Switzerland during the summer. From 20 May until the end of June Kirchner returns to Germany once more. He visits Ernst Gosebruch in Essen in prepara-

tion for the mural commission, and meets the art dealer, Ferdinand Möller, in Berlin. The nudes in outdoor settings become a dominating subject for Kirchner; major works created this year include *Nude in Orange and Yellow* (25).

1930 The famous dancer Gret Palucca performs in Davos and is Kirchner's guest. He creates important works such as *Trabergespann* (Pair of Trotting Horses), *Liebespaar – Der Kuß* (Lovers – The Kiss) and *Farbentanz I* (Colour Dance I).

1931 Kirchner participates in the exhibitions *German Paintings and Sculpture* at the Museum of Modern Art in New York and *L'Art vivant en Europe* in Brussels. In mid-June he travels to Frankfurt and Berlin, where he is appointed a member of the Prussian Academy of Arts. He establishes contact with the director of the Bern Kunsthalle, Dr. Max Huggler. The second volume of Gustav Schiefler's *Die Graphik Ernst Ludwig Kirchners* is published in Berlin.

1932 In early January Kirchner travels to Berlin, where Erna has undergone surgery, and returns to Davos with her. He urges his physician, Dr. Bauer, to prescribe him medication containing morphine. Alfred Döblin visits Kirchner while on a lecture tour of Germany and Switzerland. Developments in the art market in Germany, which is of particular importance to Kirchner, become increasingly worrisome. He starts preparing for the largest retrospective to be held during his lifetime, which is presented at the Bern Kunsthalle in 1933. Major works of this year are *Springende Tänzerin – Gret Palucca* (Rushing Dancer – Gret Palucca) and *Blonde Frau im roten Kleid – Bildnis Elisabeth Hembus* (Blonde Woman in Red Dress – Portrait of Elisabeth Hembus).

1933 The catalogue accompanying the exhibition includes the final essay written under the pen name Louis de Marsalle, whom Kirchner declares dead. In spite of the National Socialist "seizure of power" on 30 January, Kirchner's works continue at first to be acquired with public funds. In May Kirchner is called upon to relinquish his membership in the Prussian Academy of Arts. He works mainly on colour woodcuts.

1934 Ernst Gosebruch is removed from his post as Director of the Folkwang Museum; thus any hope of realising Kirchner's designs for the central hall is dashed for good. Oskar Schlemmer, the Bauhaus artist, visits Kirchner in Davos and reports on the worsening political situation in Germany. Kirchner's works are removed from display in increasing numbers of museums. He meets Paul Klee in Bern.

1935-36 In May–June the print room of the Kunstmuseum Bern shows watercolours and drawings by Kirchner. *Balkonszene* (Balcony Scene, 29) is the main work created this year. Wilhelm R. Valentiner, director of the Detroit Institute of Art, offers the artist a first solo exhibition in the U.S., which is realised the following year. During the summer Kirchner sculpts a five-figure relief for the portal of the new school building in Davos. He learns of the dissolution of the "Association of German Artists". Kirchner's health becomes increasingly problematic.

1937 639 works by Kirchner are removed from museums in Germany as "degenerate art"; some are subsequently sold abroad or destroyed. In late July Kirchner is excluded from the Prussian Academy of Arts. Kirchner considers applying for Swiss citizenship. The Buchholz Gallery Curt Valentin in New York and the Basel Kunsthalle present Kirchner's work.

1938 The *Anschluss* of Austria into Germany on 13 March fuels Kirchner's fear that the Germans could invade Switzerland as well. He destroys numerous printing blocks and some sculptures. Kirchner officially gives notice of his intended marriage with Erna, but withdraws the application four weeks later. On 15 June he commits suicide by shooting himself; he is laid to rest at the Waldfriedhof cemetery in Davos. Erna Schilling, who is officially allowed to carry the name Kirchner, continues to live at the Wildboden house until her death on 4 October 1945.

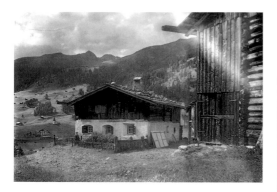

40 View of the Wildboden house,
after 1924

41 The "sculpture studio" beside the
Wildboden house with sculptures by
Hermann Scherer and Kirchner, 1924

42 Erna Schilling on the porch of
the Wildboden house, 1925–1935

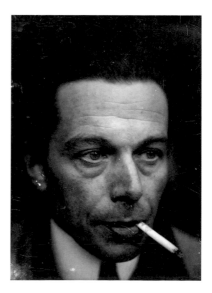

43 Self-portrait, after 1935

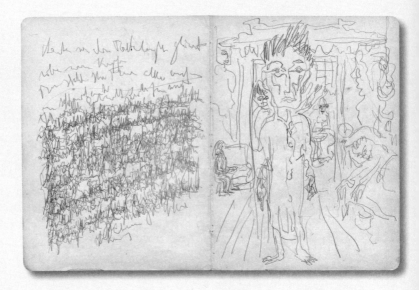

Sketchbook 54, 1917–18, pencil on paper, fol. 6,
Kirchner Museum Davos

ARCHIVE

Finds, Letters, Documents
1906–1932

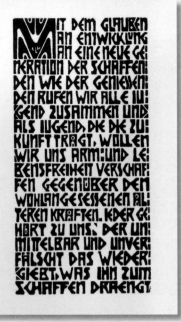

I

I

When the architecture students Ernst Ludwig Kirchner, Karl Schmidt-Rottluff,
Fritz Bleyl and Erich Heckel formed the "Brücke" artists' group in Dresden on
7 June 1905, they saw themselves as young, revolutionary forces who rebelled
against the Wilhelmine establishment with their radical new art. The works of
the "Brücke" artists reflected their emotions and the inner experience of the
world. At the same time, they sought to achieve an enhanced expressiveness by
reducing forms to their essentials. Their ambitions – as Kirchner in particular
would pursue them – are already evident in their manifesto which they
published in 1906:

With faith in evolution, in a new generation of creators and connoisseurs,
we call together all youth. And as youths, who embody the future, we want
to free our lives and limbs from the long-established older powers. Anyone
who renders his creative drive directly and genuinely is one of us.

The "Brücke" artists exhibited together as late as April 1912, but their increasingly individualised approach, in addition to the Chronicle Kirchner wrote in which he elevated his own role within the artists' group, led to alienation and, ultimately, to the dissolution of the "Brücke" on 27 May 1913.

2

In their so-called quarter-hour nudes, Ernst Ludwig Kirchner and his fellow "Brücke" artists captured their models in "wildly drawn" sketches. Even though Kirchner started reflecting on the key role of his drawings within his work only in 1917, his early works were already created "in the ecstasy of immediate experience", as he would later describe this process. In 1919 he noted in one of his sketchbooks:

The best touchstone for the artistic practice of one who creates is the drawing, the sketch. In their immediate ecstasy, drawings capture the purest and subtlest feelings of the creative individual at the surface in

2a

1 Manifesto of the Brücke Artists' Group – text, 1906, woodcut,
Kirchner Museum Davos
2a *Nude Dancing in the Studio*, c. 1911, charcoal on paper,
Kirchner Museum Davos

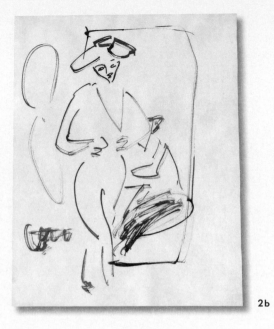

2b

finished hieroglyphs, thereby providing the most secure foundation for the composition of the painting or sculpture.

In September 1925 he wrote in his Davos diary:

How foolishly and superficially people judge; they do not see that the ephemeral nature is essential to my drawings, because through it I capture the most subtle initial sensation. If I were to make such a drawing slowly, that first delicate feeling would be lost, and that is precisely what I want to get down and what I indeed achieve in the drawings.

2b *Dodo Dancing in the Studio*, c. 1911, ink on paper,
Kirchner Museum Davos
3a *Fehmarn Coast with Yellow Nude*, 1913, watercolour over pencil
on paper, Kirchner Museum Davos

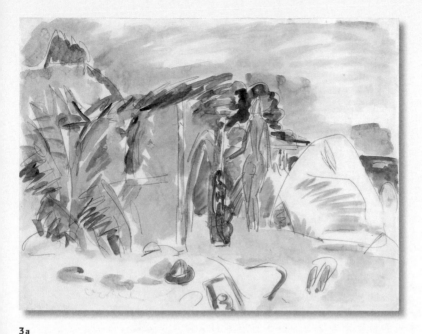

3a

3

In the summer of 1912, Kirchner took his new partner, the dancer Erna Schilling, to the Baltic island of Fehmarn for the first time. He had already discovered it in 1908 as his Arcadia, a place to lead a primitive, authentic life in nature. The island was still barely open to tourism at the time and its varied landscape promised Kirchner a rich choice of subjects. He built a hut on the stony beach which he documented in a watercoloured drawing and described in a letter to Hans Gewecke dated 24 September:

Imagine: we even built a hut on the beach with a palatial entrance. ... It is wonderful to sit in it. I built it in such a way that you can see the sea over a pink rock.

With the outbreak of World War I, Fehmarn was declared a strategically important military zone on 1 August 1914, forcing Kirchner and Erna to leave abruptly.
The war threw Kirchner into a profound existential crisis which greatly impaired his health. Given this seemingly hopeless situation, he conferred power

Power of Attorney

I hereby grant my caregiver and associate, Erna Schilling of Berlin, referred to as Frau Kirchner, power of attorney to execute all my business and legally required actions on my behalf and legally to sign all documents with my name, E L Kirchner.

Kreuzlingen,
6 July 1918
Ernst Ludwig
Kirchner

3b

of attorney over his work on Erna in 1918, which was to be valid in the event of his death as well.

Erna remained by Kirchner's side until his suicide on 15 June 1938. Her letter to Carl Hagemann on 9 July evokes the despair to which the artist had fallen prey:

The defamation in Germany was a cause of tremendous emotional suffering for Kirchner. On top of that, he felt he was in a vacuum here in Switzerland as well. I cannot give you details now. … He left behind a horrendous chaos. Everything rests on my shoulders. I am on the verge of collapsing. … In recent years we have become dreadfully isolated due, of course, to his physical condition. I see only darkness before me.

The French poet, art critic and physician Louis de Marsalle was a figment of Ernst Ludwig Kirchner's imagination. Between 1920 and 1933 the artist published a total of six texts under this nom de plume. With the help of his "French friend" he wanted to prove that his work had evolved completely independently of contemporary French art. The exotic perspective on his own circumstances was intended to communicate objectivity and autonomy, since Louis de Marsalle embodied the progressive French spirit and passed his aesthetic judgements with the authority of the well-travelled stranger. On 21 January 1920 Kirchner wrote in a letter to Ernst Gosebruch:

… I have met a young French poet here. I am amazed and delighted at how calmly, objectively, unpretentiously and intelligibly he reflects and writes on art. He is very interested in my work and will write about my drawings. Why doesn't this exist in Germany? Why do the Germans kill their artists by putting them on pedestals and worshipping them like the golden calf? Why can they not focus on the work and forget the author? … When the Frenchman bought his first watercolour from me and l wanted to sign it for him, he said: "How irrelevant is the name for an artwork!" These are details, of course, and yet they are so revealing.

Through this fictional character Kirchner not only conducted smart self-marketing; he also created an alter ego he could send on imaginary journeys to Africa, while he himself led a very secluded life in the Swiss mountains. On 30 September 1925 Kirchner wrote in a letter to Will Grohmann:

De Marsalle is reportedly in Sudan but, please, have the fee for the essay on the sculptures sent to me here. I will acknowledge receipt on his behalf and deliver the money to him another time. No reaction from the publisher yet …

Louis de Marsalle made a final appearance in the catalogue for the major retrospective at the Bern Kunsthalle in the spring of 1933. Kirchner placed a

3b Power of Attorney by Ernst Ludwig Kirchner, Kreuzlingen 1918, Kirchner Museum Davos

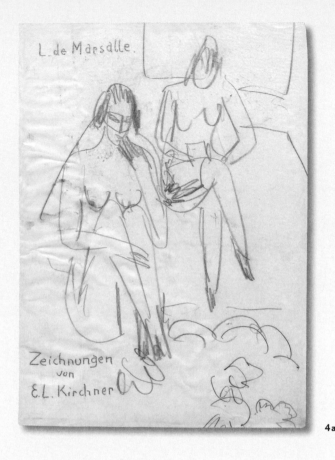

Zeichnungen
von
E.L. Kirchner

4a

dagger symbol behind the name of his fictional character. Already in December
of the previous year, 1932, he had made the following statement in a letter to
Max Huggler, the director of the museum:

As for an introduction, I have found an old, as yet unpublished text by my
late friend de Marsalle who explains the change in style in very simple
terms. I will be happy to edit it carefully and very much hope to have your
kind support, so the end result will be superb. I always learn a lot with re-
gard to my paintings from preparing such exhibitions; this kind of work is
therefore never lost. Hanging an exhibition in the proper manner and fi-
nalising it is, indeed, the same as creating a painting. We have so much
material here that we can go about selecting works without constraints.

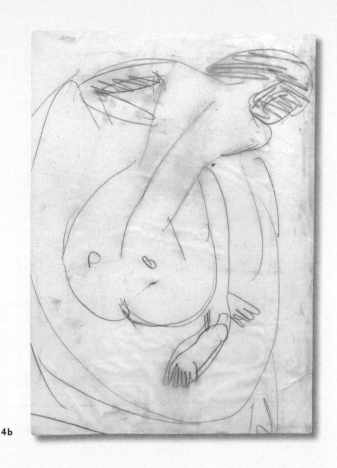

4b

This surely will be a pleasure and delight and will compensate us for the expected battles and expenditures. The cover of the catalogue should, perhaps, simply have the name "E. L. Kirchner" written on it with a brush. That looks very elegant and yet characteristic. We will have many visitors coming from out of town. …

4a, b Two drawings by E. L. Kirchner, cover for a reprint of the essay "L. de Marsalle: Zeichnungen von E. L. Kirchner", 1921, Kirchner Museum Davos

SOURCES

EXCERPTS WERE TAKEN FROM THE FOLLOWING BIBLIOGRAPHICAL SOURCES

Hans Delfs (ed.), *Ernst Ludwig Kirchner. Der gesamte Briefwechsel*, 4 vols. (Zurich 2010): 75, 76, 77
Andreas Gabelmann, *Ernst Ludwig Kirchner. Ein Künstlerleben in Selbstzeugnissen* (Ostfildern 2010), pp. 41, 86: 73, 74
Lothar Grisebach, *Ernst Ludwig Kirchners Davoser Tagebuch. Eine Darstellung des Malers und seine Sammlung seiner Schriften* (Cologne 1968, new edition revised by Lucius Grisebach (Ostfildern-Ruit, 1997), p. 88: 72 bottom.
Gerd Presler, *Ernst Ludwig Kirchner. Die Skizzenbücher. "Ekstase des ersten Sehens"*. Monograph and catalogue raisonné ed. by Jürgen Döhmann and Gerd Presler (Karlsruhe 1996), sketchbook. 69/14–15, p. 49: 72

Published by
Hirmer Verlag GmbH
Nymphenburger Strasse 84
80636 Munich
Germany

Front cover: *Nude in Orange and Yellow* (detail),
1929–30, see p. 43
Double page 2/3: *Two Women with Washbasin
(The Sisters)* (detail), 1913, see p. 17
Double page 4/5: *Davos with Church; Davos in
Summer* (detail), 1925, see p. 39

www.hirmerpublishers.com

—
TRANSLATION
Bram Opstelten
—
COPY-EDITING/PROOFREADING
Jane Michael
—
PROJECT MANAGEMENT
Anne Funck
—
DESIGN/TYPESETTING
Marion Blomeyer, Rainald Schwarz
—
PRE-PRESS/REPRO
Reproline mediateam GmbH, Munich
—
PAPER
LuxoArt samt new
—
PRINTING/BINDING
Passavia Druckservice GmbH & Co. KG, Passau

Bibliographic information published by the
Deutsche Nationalbibliothek
The Deutsche Nationalbibliothek lists this
publication in the Deutsche Nationalbibliografie;
detailed bibliographic data are available on the
Internet at http://dnb.dnb.de .

ISBN 978-3-7774-2958-8

Printed in Germany

THE GREAT MASTERS OF ART SERIES

ALREADY PUBLISHED

PAUL GAUGUIN
978-3-7774-2854-3

EMIL NOLDE
978-3-7774-2774-4

RICHARD GERSTL
978-3-7774-2622-8

PABLO PICASSO
978-3-7774-2757-7

VASILY KANDINSKY
978-3-7774-2759-1

EGON SCHIELE
978-3-7774-2852-9

HENRI MATISSE
978-3-7774-2848-2

VINCENT VAN GOGH
978-3-7774-2758-4

www.hirmerpublishers.com